AN OUTHOUSE
BY ANY OTHER NAME

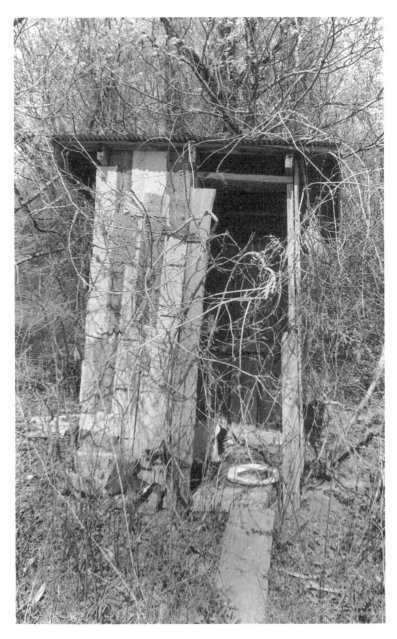

This very "vine" relief station resides along Route 70 near Pine Bluff.

AN OUTHOUSE
BY ANY OTHER NAME

THOMAS HARDING

August House Publishers, Inc.
LITTLE ROCK

Dedicated to my lovely wife Helen

All Photographs: Thomas Harding
Project Editor: Joy Freeman
Manuscript Editor: Jody McNeese

The paper used in this publication meets the minimum requirements of the
American National Standard for Information Sciences—Permanence of Paper for
Printed Library materials, ANSI Z39.48-1984.

AUGUST HOUSE, INC. PUBLISHERS LITTLE ROCK

About the Photographer

Thomas Harding was born in 1911, the son and grandson of prominent Little Rock architects, also named Thomas Harding. He grew up in downtown Little Rock, graduated from Little Rock Senior High School (now Central High), and studied architecture at Washington University in St. Louis. He worked for a time in the Memphis defense depot, where he met his wife, Helen. During World War II, he was a sergeant in the Army air force on the staff of General Ira C. Eaker. He eventually became a kind of roving staff photographer for Eaker's headquarters.

After the war, he promised his father he'd give architecture a try. He lasted a few months before he did what he really wanted to do and opened his photography studio. For almost twenty years, a portrait by Harding was a Little Rock ritual. Harding joined the famous Bachrach Photographers in 1964 in their New York studio. There he specialized in portraits of initially women, then men. In 1970, he returned to Little Rock, this time as a commercial photographer.

After his formal retirement in 1981, Harding reduced his photography to its essence of light and shadow, doing still lifes in black and white. Most of his work is done in natural light with pinhole cameras he makes himself. His photographs are exhibited and published nationwide and hang in many private and public collections. His pictures of rural schoolhouses were collected in the book *One-Room Schoolhouses of Arkansas as Seen through a Pinhole* (University of Arkansas Press, 1993). After schoolhouses, he focused on outhouses. He says they're fun; the

pictures also combine his love of Arkansas history with photography of deceptive simplicity.

Harding's wife, Helen, died in 1996, after 55 years of marriage. A son, also Thomas Harding, is in the construction business in Little Rock.

About the Pictures

Most of the photographs in this book were made with a Pentax 120 35mm zoom. The film was Ilford HP5, developed in HCI10.

About one third of the photographs were made with a pinhole camera of my own construction. I glued two pieces of three-quarter inch plywood, then drilled a hole through the wood. I attached a piece of brass with a pinhole in it over the hole in front. To the pinhole I fixed a Packard Air Release Shutter. Behind the hole, to hold the sheet film, I attached the back of a 4x5 Speed Graphic camera. The f-stop is f-128 and the field of view is about 120 degrees. The film for the pinhole camera was also HP5, developed in HCI10.

Acknowledgments

I wish to thank Peg Smith and Susan Miller, affectionately called "The Committee," who shared in the adventure of sleuthing out these diversified gems of Arkansas architecture. To them and our one-day "search trips," I am most grateful and have the fondest memories. To Dr. T. Harri Baker for reading the manuscript and supporting me with guidance and encouragement. To Ellen Bard of the Central Arkansas Library System for her enthusiasm and support in securing desired information for this book. Any errors in the work are my own responsibility—*errare humanum est.*

Arkansas Outhouses: An Introduction

Several years ago while I was photographing an old building out in the country, I had a sudden urge toward "nature's call." Quickly looking around, I spotted an old outhouse standing in a wide open field where several workers were planting a crop. I asked if I could use the outhouse and was thankful to get in reply, "Sure, go ahead."

The episode caused me to reflect on how people in years past managed the disposal of human waste and particularly on the outhouse or privy, once common and now rare, hardly ever spoken of, much less photographed.

I like old buildings, I like roaming around the Arkansas back roads, and I like photography. And I don't much mind doing things that other people might think unconventional. So, for the fun of it, I started taking photographs of Arkansas outhouses, mostly with one of my pinhole cameras.

Once common, outhouses are getting harder to find. Friends told me about some, and good folks along the road told me about others. Some I spotted myself while driving randomly along the back roads. Time, neglect, and the weather have taken their toll on most of the survivors, leaving them run down and not repairable. At their best, they were little gems of folk architecture; in some ways it seems to me a tragedy that they were hardly ever noticed and now are disappearing.

If you hunt hard enough, you can find records about the disposal of human waste. The Bible (Deuteronomy 23:12-13) gives some precise instructions, and archeological evidence, usually from surviving grand buildings, shows that the Minoans, the Greeks, and the Romans sometimes had indoor toilets over streams of running water.

Medieval castles had privy rooms with stools over a hole in the floor that emptied into a container or directly into the moat below. City folks in those times just threw waste out the window into the street and hoped it rained soon. Rural areas had some version of an outhouse early on.

It took urbanization and the Industrial Revolution to bring significant change, as typified by the work of the Englishman Thomas Crapper in the 1870s. A sanitary engineer, he invented the valve that made the flush toilet possible.

Well into the twentieth century, however, in places such as rural Arkansas, there were still the outhouses. Mostly wooden, sometimes sheet metal, rarely stone and more rarely brick, they were one-holers, two-holers, and sometimes even three-holers. A friend of mine, a Native American, lived far back in the hollows of the Ozarks, where he built himself a "backhouse" with three walls and a roof. Following what he called an old tradition, the open side faced east, toward the morning sun.

Outhouses were ideally located close enough to the house to be convenient and far away enough to be sanitary, although it was only in this century that people made the connection among sanitation, germs, and disease. For example, in warm climates—such as Arkansas and the rest of the American South—hookworm was an unknown scourge. The hookworm parasite lays eggs in the human intestine that exit along with human waste. If those eggs fall on moist and sandy soil, they turn into larva that can burrow into bare feet. The larvae move through the bloodstream to the lungs and throat, and thence to the stomach and intestines to start the process all over again. A person with hookworms might not know of the infestation, but he or she would be tired and listless, probably anemic, and susceptible to diseases. Or as someone said when the hookworm was identified, it was the South's "germ of laziness." Badly-drained outhouses among a people too poor to always wear shoes was of course a recipe for hookworm. The same circumstances also contributed to diarrhea, dysentery, typhoid fever, and other diseases.

Hookworm wasn't scientifically identified until 1902. With funds from oil-money philanthropist John D. Rockefeller, the

Rockefeller Sanitary Commission for the Eradication of Hookworm Disease tried to measure the incidence of the disease in the South around 1912. In one sample from Arkansas, almost one-third had hookworm. The Rockefeller Commission also ran educational programs that gave advice on how to build outhouses. Many Arkansans regarded this as typical Yankee meddling, offensive and unnecessary.

Gradually, into the 1920s and 1930s, the number of outhouses declined with the increase in medical knowledge, safe water systems, and urbanization. In the 1930s the New Deal's Works Progress Administration built scientifically designed privies at five dollars each or free to those who couldn't afford them. The WPA put up more than 51,000 privies in Arkansas alone.

As late as the 1950s the Bureau of Sanitary Engineering of the State Board of Health offered a pamphlet on "The Sanitary Pit Privy—Single Unit," with a materials list, working drawings, and location recommendations.

Of the privies I've photographed, probably the most common are the surface privy and pit privy, both of which were supposed to be moved periodically, and the vault privy with its water-tight concrete vault.

One last observation: for a convenience people often didn't speak about, a remarkable number of names exist for it. I've used outhouse and privy interchangeably here, as most Arkansans probably would, but there are also these terms: necessary, backhouse, backy, can, john, johnny, chick sale, throne room, and, for the army and navy veterans, latrine or head. For the multicultured and well-traveled reader, the British term loo comes from the French phrase *les lieux d'aisances*, "the places of convenience."

And now join me on a journey through the back roads of Arkansas for what remains a sort of folk tradition.

—Thomas Harding

It was the best of times,

it was the worst of times.

—Charles Dickens

This one-hole pit privy owned by Christian Seck
is located on Petit Jean Mountain.

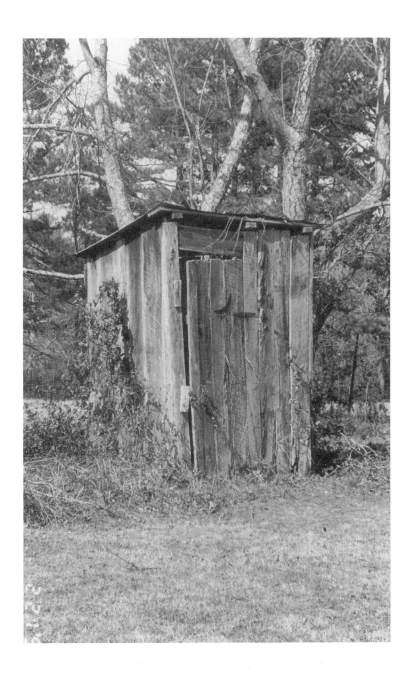

The longest part of the journey

is said to be the passing of the gate.

—Marcus Terentius Varro

This necessary house, built around 1960, is back
of the Idlewild school outside of DeValls Bluff.

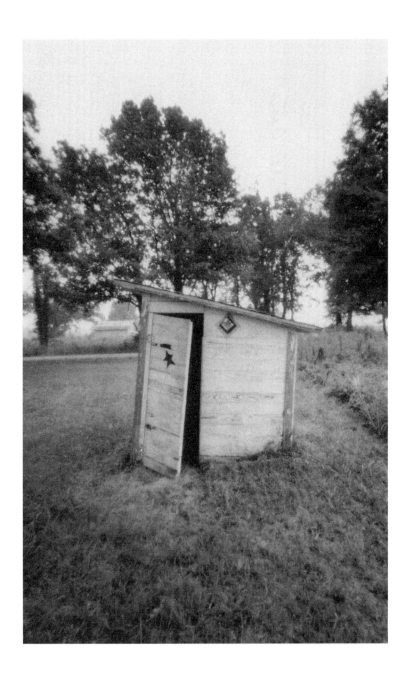

The very rats

Instinctively have quit it.

—William Shakespeare

The Lassiter Farm sports this lonely one-holer
near Sidney, built around 1960.

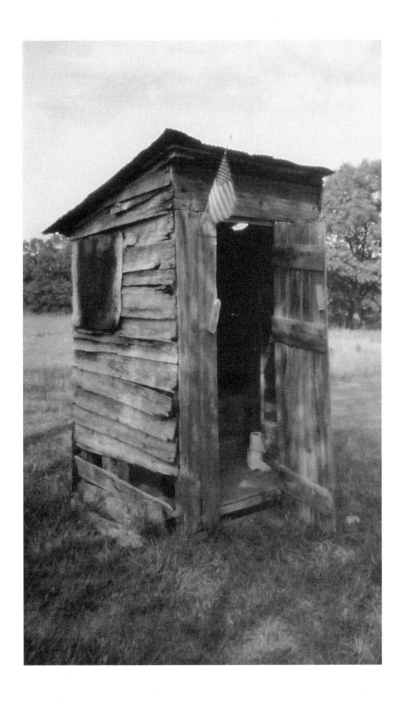

My joy, my grief, my hope, my love,

Did all within this circle move!

—Edmund Waller

Buddy Murray's two-hole privy has one seat lower
for the young 'uns. It rests on runners for ease
in changing location. It was built around
1970 off Highway 284 near Fair Oaks.

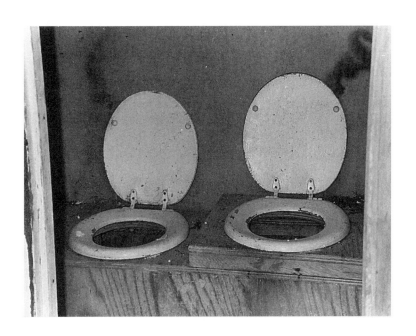

But now my task is smoothly done:

I can fly, or I can run.

—John Milton

This privy, with walls made from old metal signs, was built around 1970, and is located near the old Main Gate to the Fairfield Bay Community.

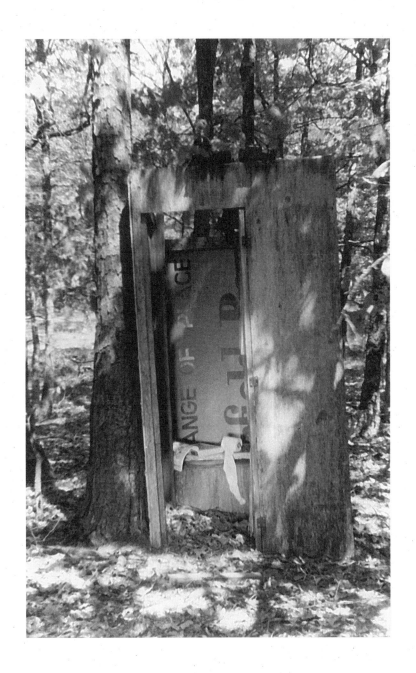

When she had passed,

it seemed like the ceasing of exquisite music.

—Henry Wadsworth Longfellow

This outhouse near Kingston is naturally air-conditioned. Its construction date is unknown.

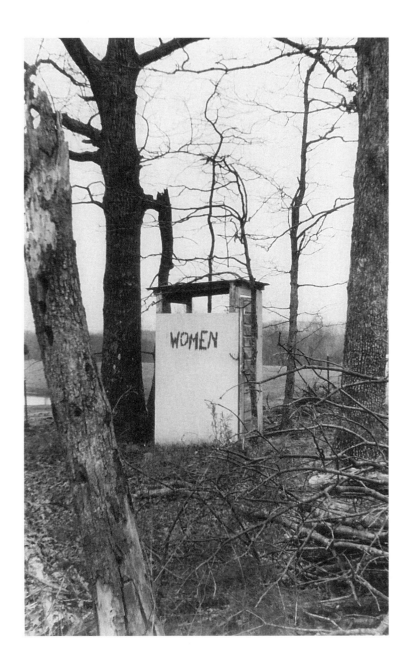

To strive, to seek, to find,

and not to yield.

—Alfred, Lord Tennyson

This door detail is from George Fisher's
1965 outhouse, which is found next door
to Jimmy Driftwood's house in Timbo.

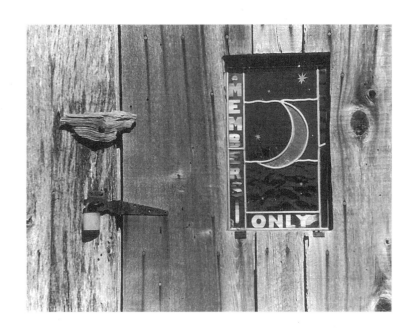

Who is the Potter, pray,

and who the Pot?

—Edward FitzGerald

This outhouse, owned by Mary Gehring
of New Blaine, is most unusual in that
it has a chicken house attached to it.
It was built around 1955.

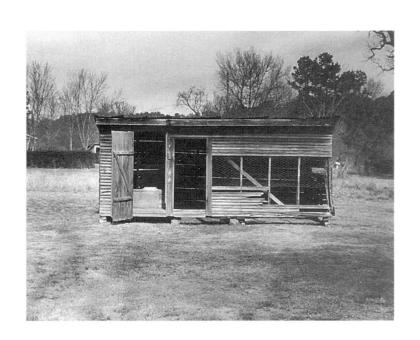

Here I am, and here I stay.

—Maurice de MacMahon

This man, armed with the Sears and Roebuck
catalog and corn cobs, was seen rushing into the
Jernigan 1960 outhouse near Buckhorn.

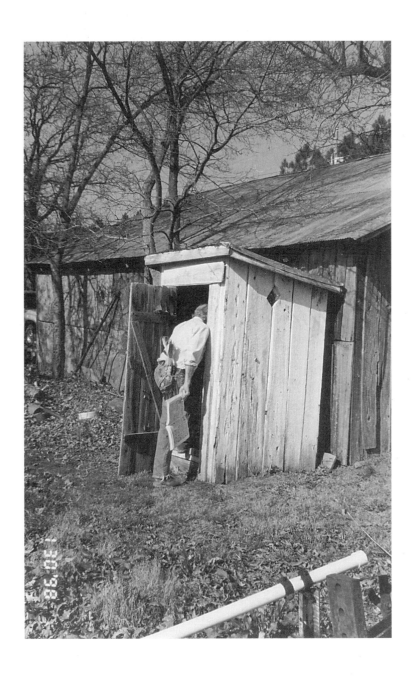

Not even the gods fight against necessity.

—The Seven Sages

The old metal tank seen here functioned
for the men, while the women used the
wood structure. The construction dates of
these outhouses in Madison are unknown.

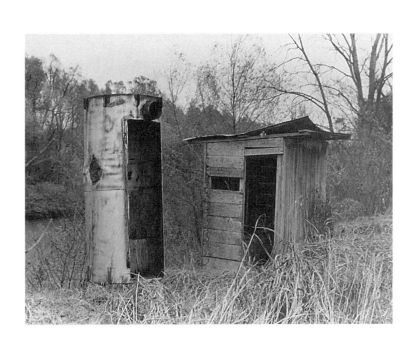

Of a good beginning cometh a good end.

—John Heywood

Sterling Cockrill built his own lakeside privy
on Lake Hamilton in Hot Springs.

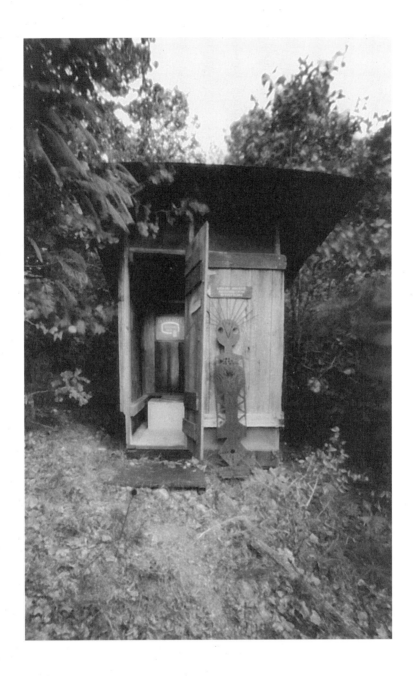

A name illustrious and revered by nations.

—Lucan

The 1936 "water closet" of John Truemper's
sports this detail. The building now has a
corrugated plastic roof and an electric light.

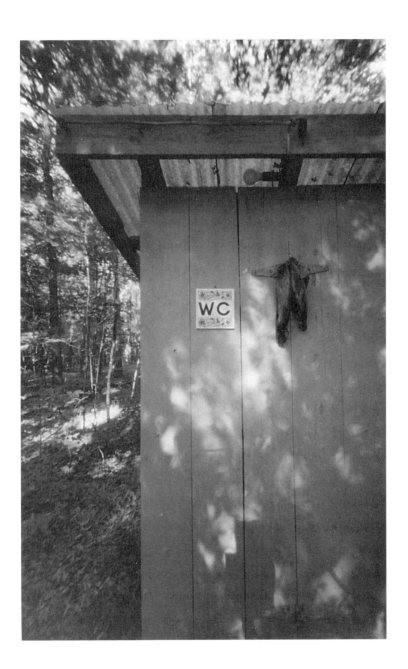

The sign brings customers.

—Jean de La Fontaine

This replica of the original privy at
Parker Westbrook's house stands in Nashville.

The hour of departure has arrived,

and we go our ways—

I to die, and you to live.

Which is better God only knows.

—Plato

This old two-hole outhouse resides at
New Briar Baptist Church in Blue Mountain.

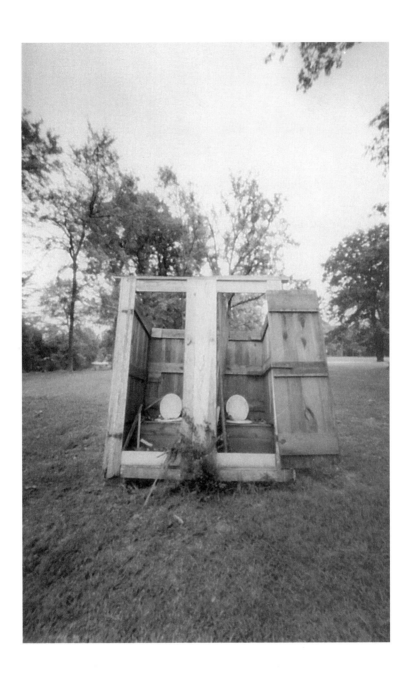

The goal of life is living in agreement with nature.

—Zeno

This single-hole privy, built in 1997, is one of three at
Joy Fox's Wattle Hollow retreat near Hog Eye. All three
have either a full-length picture window or only three sides.

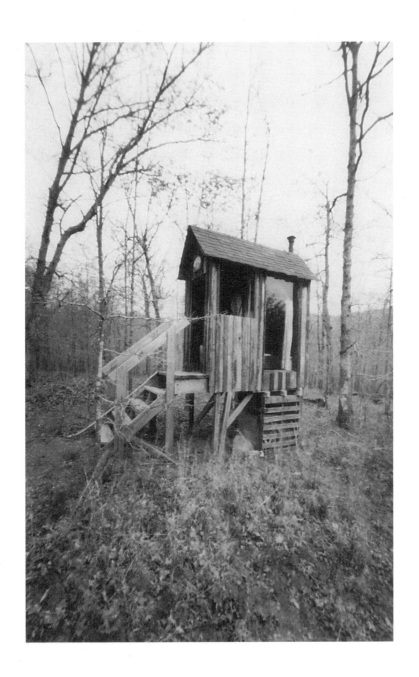

It is not fit that you sit here any longer!...

you shall now give place to better men.

—Oliver Cromwell

Stone outhouses were somewhat unusual in Arkansas. This
one-holer was found in the community of New Blaine.

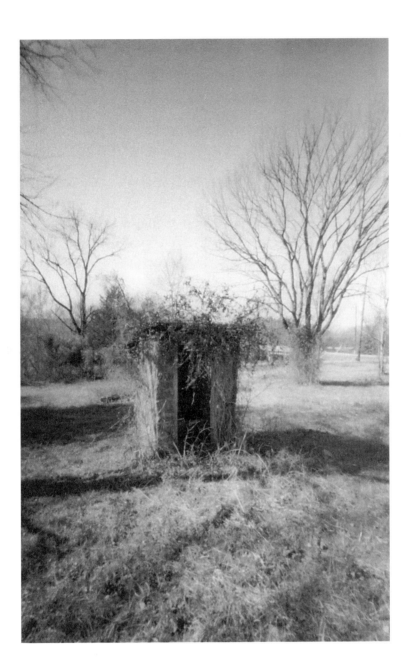

Necessity brings him here, not pleasure.

—Dante

This necessary house is on land belonging
to Mrs. Ethel Earl on Petit Jean Mountain.
The privy is inside the open door at the right.
The closed door opens to a shower room.

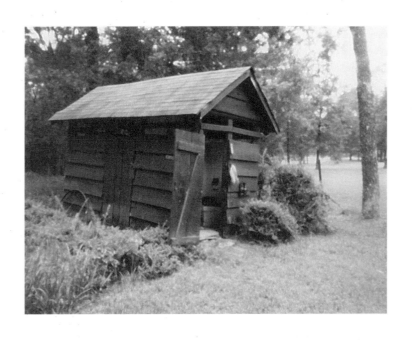

When a building is about to fall down,

all the mice desert it.

—Pliny the Elder

Very little remains of this one-hole outhouse
across from the Luber School in the
East Richwoods community, Stone County.
The WPA probably built this privy.

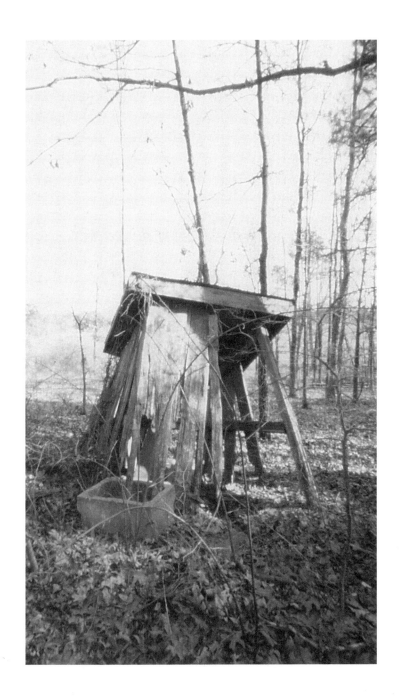

How sad and bad and mad it was—

But then, how it was sweet!

—Robert Browning

The old rusty bedstead handrail leads down to the well-stocked "library" privy with a picture window for viewing the valley and Arkansas River below. Owned by Ladd Davies, it is located on Petit Jean Mountain off Highway 154 near Morrilton.

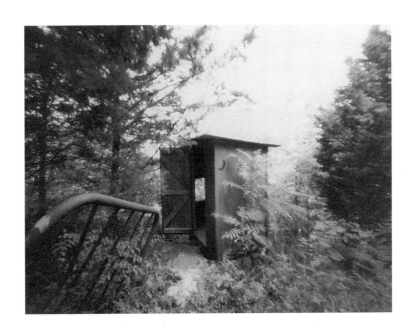

Asses are made to bear, and so are you.

—William Shakespeare

This structure is in the town of Crockett's Bluff.
Is it for real or a utility building?

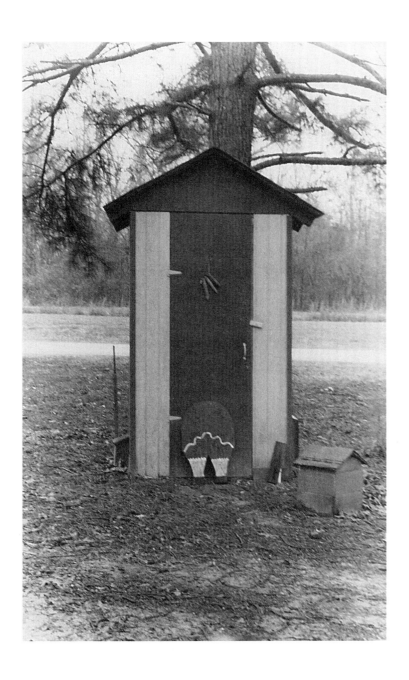

The country in town.

—Martial

Located in downtown Little Rock near the
back property line of the Charles Witsell, Jr.
residence, this outhouse was built in 1896.

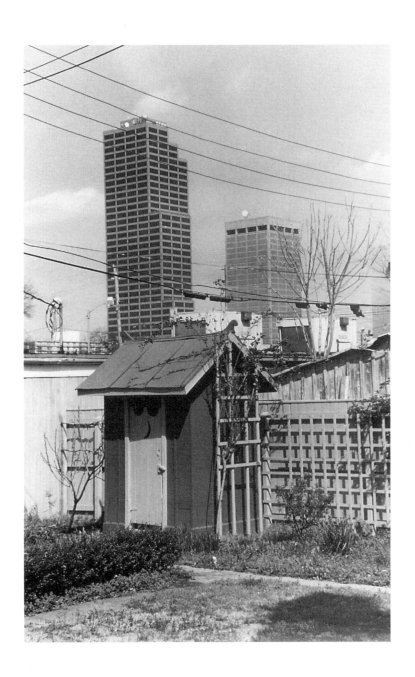

Stay far hence, far hence, you prudes!

—Ovid

Buddy Murray's two-holer rests on runners for
an easy move in case the water rises too high.
It is found off Highway 284 near Fair Oaks.

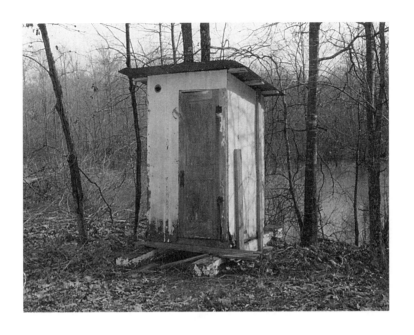

The sun too penetrates into privies,

but is not polluted by them.

—Diogenes the Cynic

This once elegant outhouse was built in 1869 in conjunction
with the Jackson County Courthouse in Jacksonport.
The exterior walls are made of handmade bricks, while the
interior walls were of walnut boards. The three openings served
as entrances to the men's, women's, and Negroes' toilets.

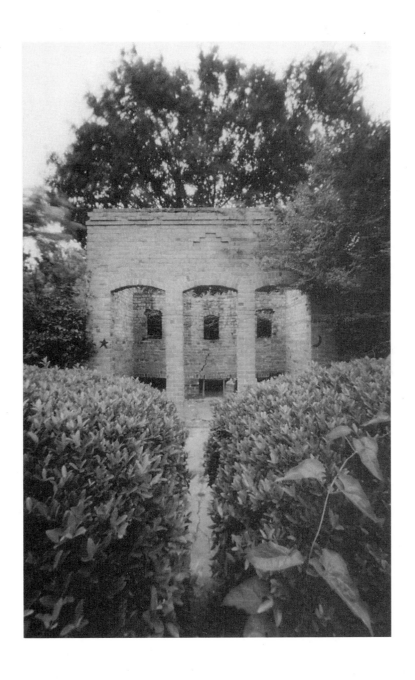

He does it with a better grace,

but I do it more natural.

—William Shakespeare

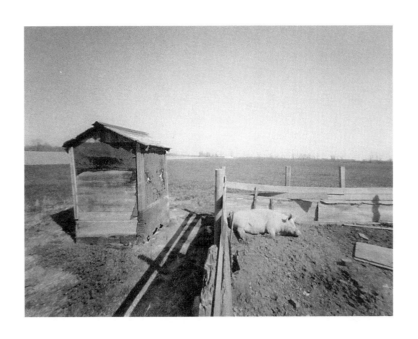

Consider the little mouse,

how sagacious an animal it is

which never entrusts its life to one hole only.

—Titus

Bill Cotham's privy rests near the bayou at Scott.
Its construction date is unknown.

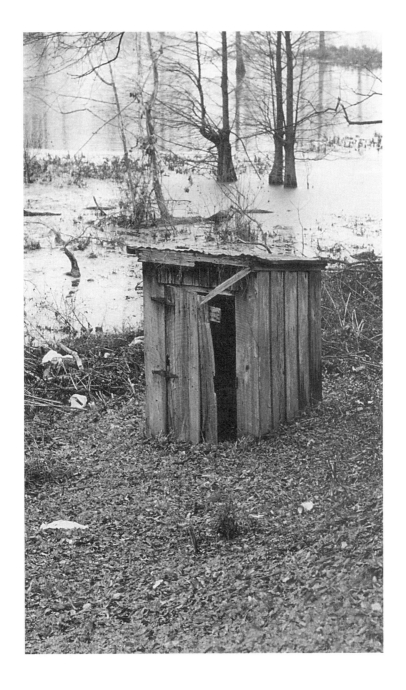

More matter, with less art.

—William Shakespeare

Florence E. Roberts owns this 1920s
three-holer located in DeValls Bluff.

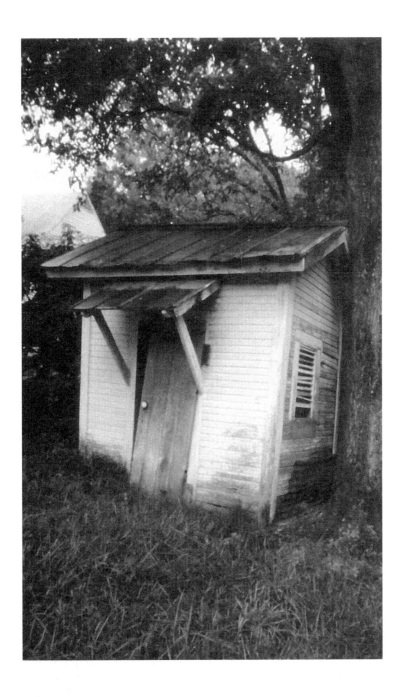

I assert that nothing ever comes to pass

without a cause.

—Jonathan Edwards

Found on Petit Jean Mountain near Morrilton,
this outhouse was built by Dudley Brown.

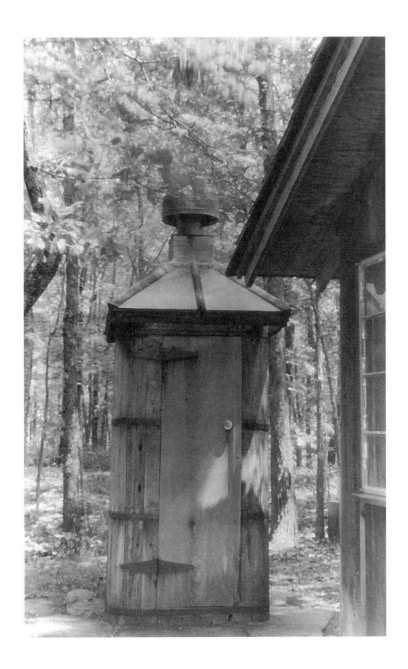

Nature speaks in symbols and in signs.

—John Greenleaf Whittier

A deer camp in southern Arkansas
sports this modern plastic toilet, which is
easily accessible to the old school bus the
hunters use for living accommodations.

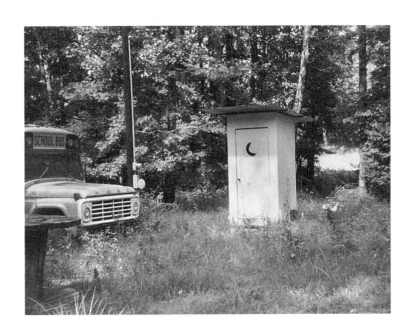

It was built against the will of the immortal gods,

and so it did not last for long.

—Homer

Mitch Aufderheide's one-holer was built by the
WPA sometime during the 1940s near Wright.

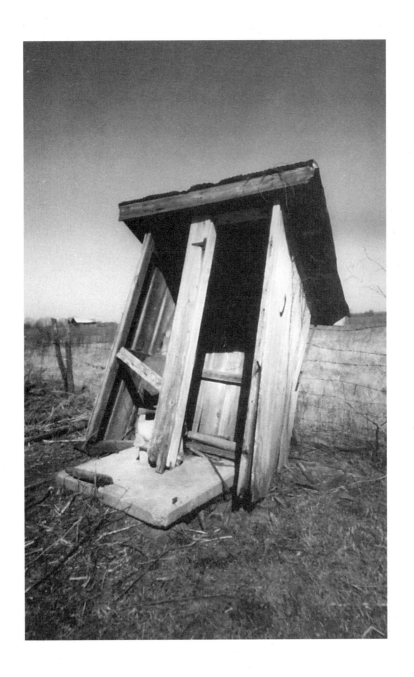

This was a good week's labor.

—Thomas Middleton

This privy on the Von Sturdavant farm, on Banner Mountain
near Fairfield Bay, sits isolated in a large open field.
The walls and roof are corrugated metal. HOT! COLD!

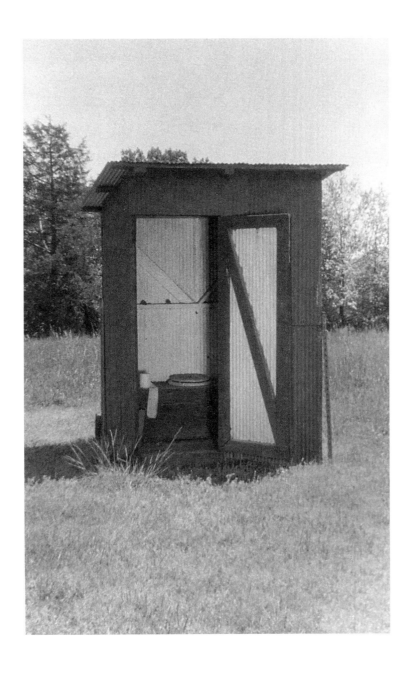

It oft falls out,

To have what we would have,

we speak not what we mean.

—William Shakespeare

This well-kept outhouse belongs to Hubert Ferguson
and is located on Highway 74 near Boxley.
Mr. Ferguson uses it as a utility shed.

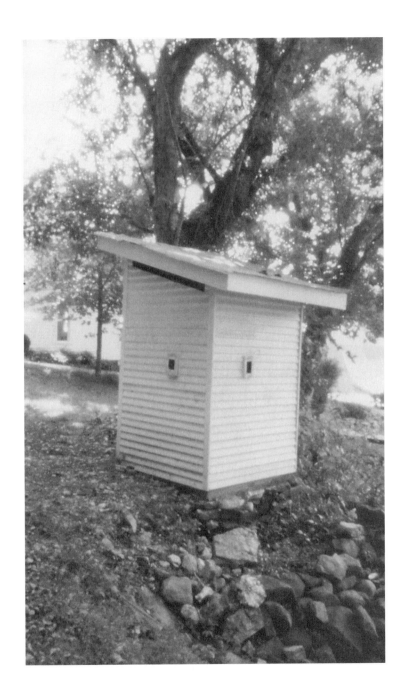

The gloomy calm of idle vacancy.

—Samuel Johnson

This well-designed privy was built around 1940 using
CCC labor in Crowley's Ridge State Park near Walcott.

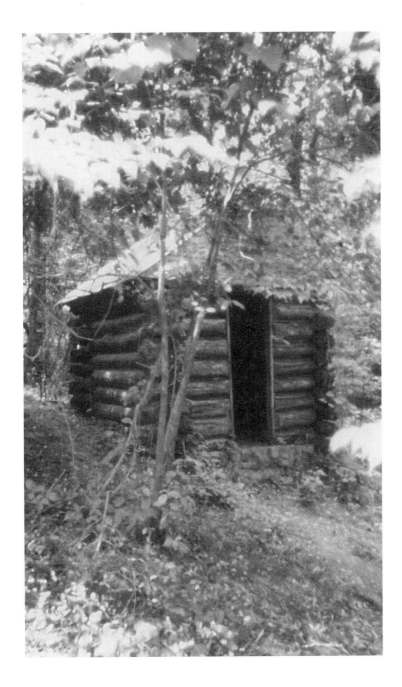

A fair exterior is a silent recommendation.

—Pubilius Syrus

This necessary was moved from the G.R. Jones farm
and given to the Agricultural Museum in Stuttgart.
Note the unusual position of the luna (moon).

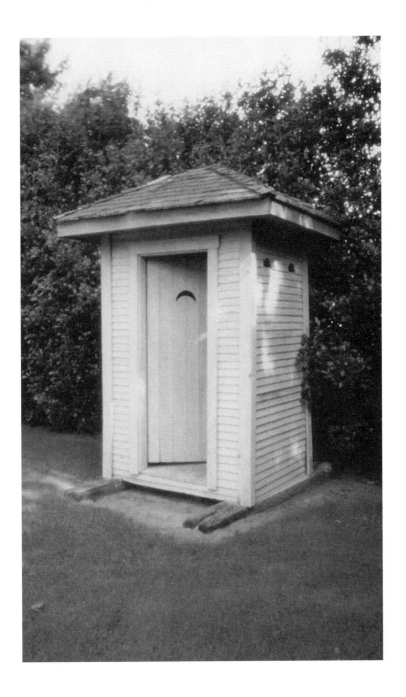

Perhaps someday it will be pleasant

to remember even this.

—Virgil

This two-holer sits next to a fishing and boating camp
on the Mulberry River near Turner Bend.
What a neat design!

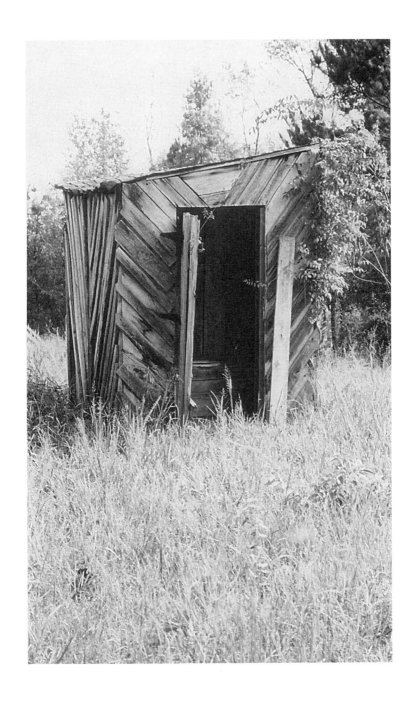

All hell shall stir for this.

—William Shakespeare

This pit privy, its surrounding structure probably
knocked down as a Halloween prank, sits next to
the United Methodist Church in Centerville.

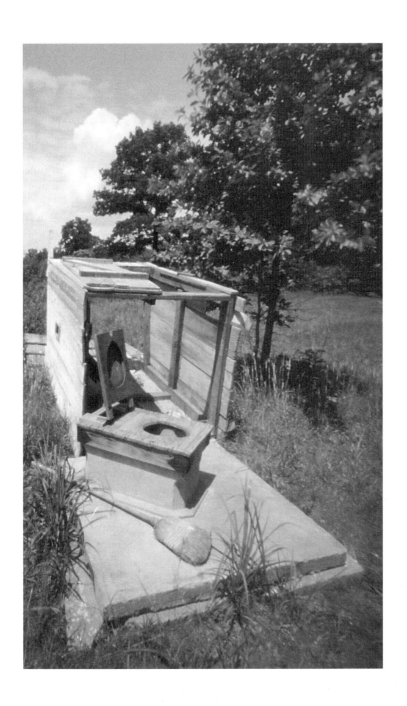

That action is the best which procures

the greatest happiness for the greatest numbers.

—Francis Hutcheson

This three-hole pit privy on an abandoned farm
near New Blaine served the whole family.

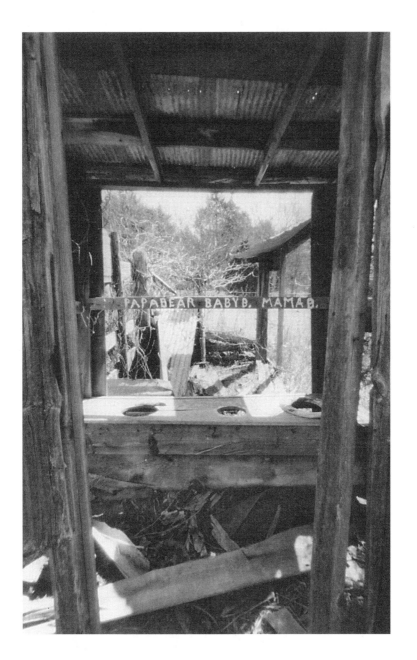

Delays have dangerous ends.

—William Shakespeare

The WPA built this rare roadside one-holer on
Herpel Road near Mountain View around 1940.

These dreary dumps.

—William Shakespeare

The Graves Cemetery near Delaware boasts these
three necessaries—two plastic ones for women
and an old wooden one for men at the back.
The sign on the tree says "No Dumping."

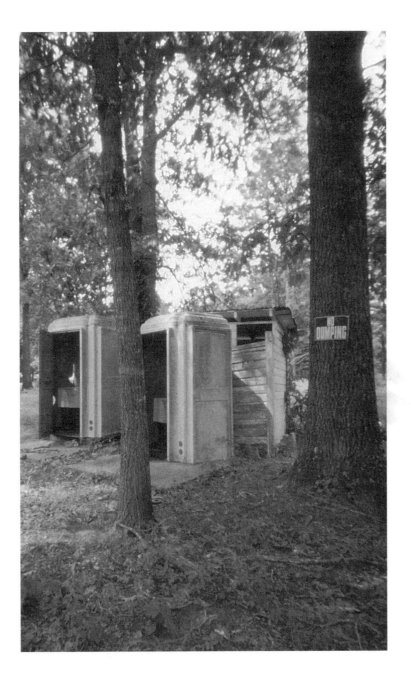

I was a stricken deer that left the herd

Long since.

—William Cowper

The WPA built this one-hole pit privy at the
junction of Highways 9 and 10 around 1938.

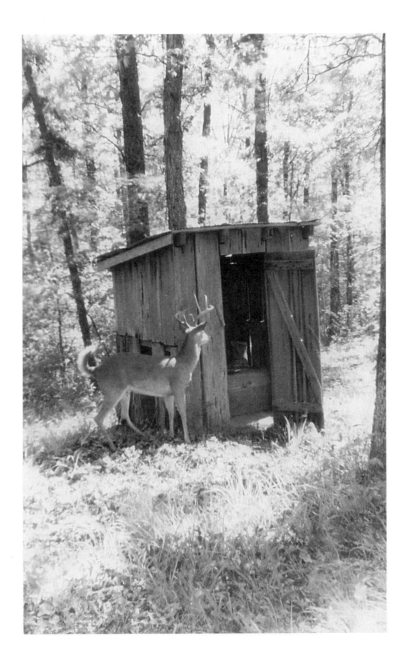

There is no odor so bad as that

which arises from goodness tainted.

—Henry David Thoreau

This pail privy is just outside a Pentecostal church
near Payneway. The pail sits under the seat
with a bucket of water outside.

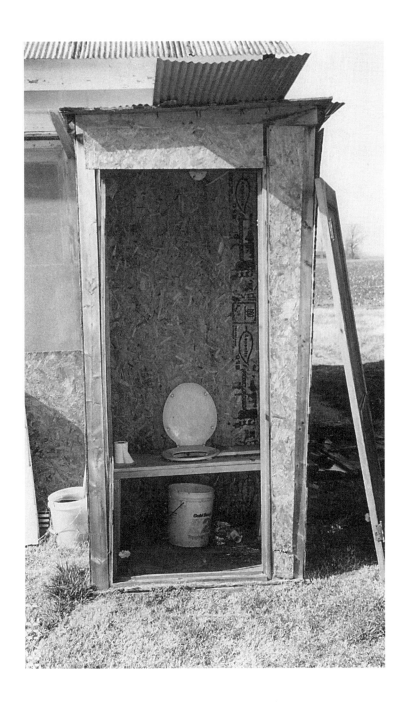

I never heard

So musical a discord, such sweet thunder.

—William Shakespeare

Phillip Longrader's privy was built during the 1950s
on his farm near Hunter. He likes to strum his
guitar with the door open while "resting."

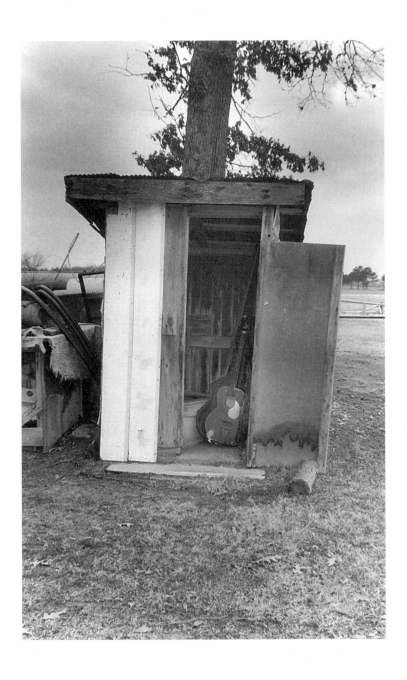

There is no greater sorrow

Than to be mindful of the happy times

In misery.

—Dante

The Black Oak Baptist Church near Fayetteville
provided users with this privacy baffle.

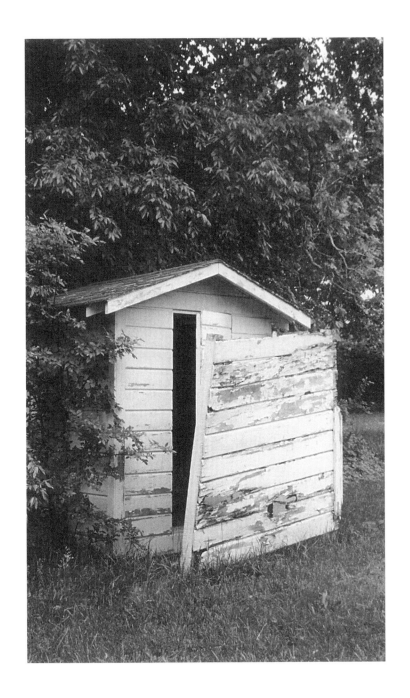

Necessity is the mistress and guardian of Nature.

—Leonardo da Vinci

This two-holer at Turner Bend has a divided interior
with entrances for men and women on opposite sides.

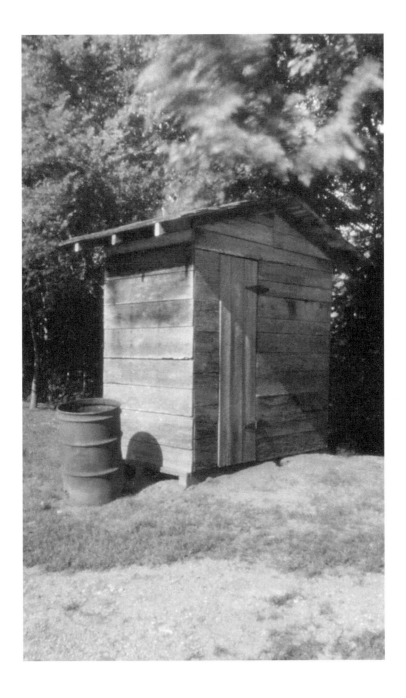

All hope abandon, ye who enter here!

—Dante